BRUEGEL

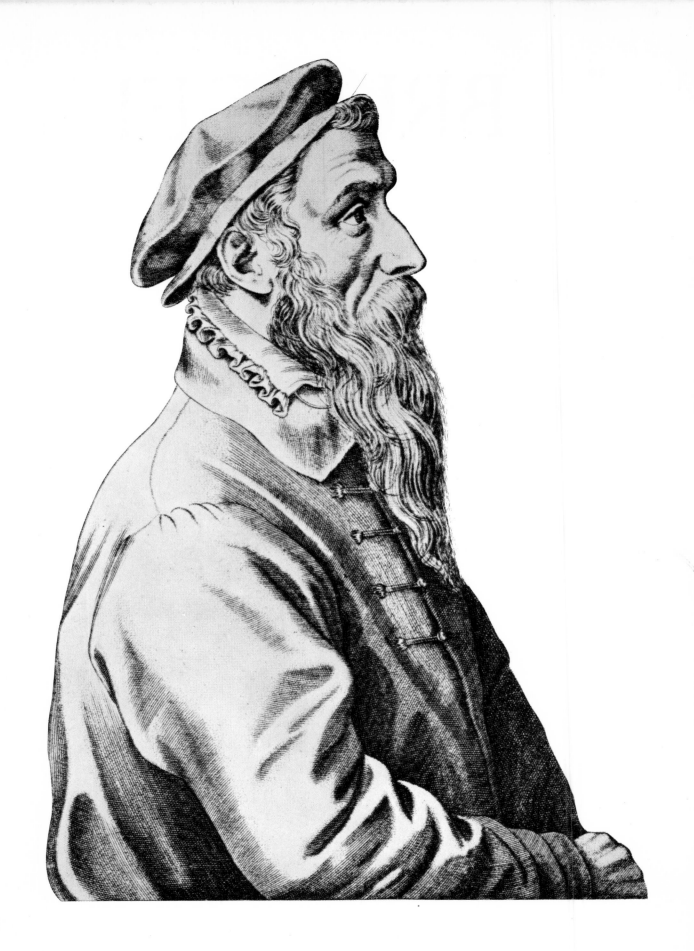

BRUEGEL

Irving L. Zupnick

Professor of Art History
State University of New York at Binghamton

McGRAW-HILL BOOK COMPANY · NEW YORK · LONDON · TORONTO · SYDNEY

Cover picture, *The Painter and the Connoisseur* (c. 1565), pen drawing, 9⅞″ x 8⅜″, Albertina, Vienna

PIETER BRUEGEL is one of the truly great artists of all time. He brought extraordinary creative vitality to an already impressive artistic tradition, and left his imprint upon the landscape and genre painters who came after him. But above and beyond his historical importance, Bruegel is fascinating as a rare individual. As an artist he created brilliant works based upon realistic observation and forceful design, but there is no doubt that his pictures were supposed to communicate and teach, as well as to appeal to our love of beauty. Today, if we are to appreciate his efforts fully, we must reassess the social commentary recorded in his work—those underlying currents made so elusive by the chasm of four centuries and by Bruegel's conscious effort to disguise his meaning from all but a select few of his contemporaries.

When we examine Bruegel's art against the background of the conditions in the Netherlands during the sixteenth century, we can understand his reluctance to popularize his views on the evils of society. His homeland, modern Belgium and Holland, was then an unwilling part of the Hapsburg domain and, as such, a part of the Holy Roman Empire. The Empire, an unwieldy, far-flung conglomerate of territories, held together by ambition rather than common necessity, was ready to burst at the seams. As one of its most prosperous areas, the Netherlands was compelled to support the Empire's geopolitical programs, even when they were inimical to its own; and the local nobility and the traditionally independent city-states found it distasteful to submit to a centralized authority directed from faraway Spain. Another basic cause of tension was the growth in the number of Anabaptists, Lutherans, and Calvinists, to the great dismay of the Catholic emperor, Philip II, who felt that it was his religious duty to obliterate them. It may be that the situation was further aggravated by the fact that the emperor was out of touch with local affairs. Ruling from Spain through a regent, his half-sister Margaret of Parma, and a council of state headed by Cardinal Granvelle, Philip reacted with sometimes confusing results to information that was either conflicting or out of sequence with events. He continually demanded harsher measures, while his

Frontispiece.
Portrait of Bruegel
engraving
Lampsonius' Effigies, 1572

[Facing this page]
Detail of Figure 8

governors, who were more aware of the mounting tension, faced one exigency at a time, keeping their foes off balance with calculated divisive measures and compromises. Finally, in 1567 Philip II lost patience and dispatched Ferdinand Alvarez de Toledo, the Duke of Alva, with an army, ordering him to install martial rule in the Netherlands and to enforce the Inquisition, which had been resisted until then with considerable success.

Remembering the circumstances that surrounded him, we should not be surprised that Bruegel displayed caution in his art, which, as an effective means of propaganda, was liable to strict governmental surveillance. He depicts subjects that often seem to have reference to current events, but his openness in revealing his ideas seems to vary in response to the strictness with which the government enforced its policies. His commitment and his sensitivity to danger are revealed by his last act, which, according to Carel van Mander, his earliest biographer, was to order his wife to burn certain drawings, which were "too biting and too sharp," either "because of remorse, or fear that the most disagreeable consequences might grow out of them."

The exact location of Bruegel's birthplace in Brabant, either in present-day Belgium or Holland, is still uncertain, and estimates of the year of his birth vary from 1520 to 1530. All we know for sure is that the name "Peeter Brueghels" first appears on the members list of the artist's guild in Antwerp in 1551, and that (according to van Mander) Bruegel was an apprentice of Pieter Coeck van Aelst, whose daughter Mayken he was to marry in 1563. Bruegel was to die in September 1569, but not before he left two very young sons who were to carry on his name and tradition. Pieter Bruegel the Younger, who was born in 1564, remained most faithful to his father's style and is responsible for many copies of his father's works, including some which have become lost. Jan Bruegel, who was to become famous in his own right as "Velvet Bruegel," was born in 1568, and had a strong influence on Baroque landscape and still life painting. In addition to his descendants, Bruegel left a rich legacy of pictorial ideas that was to influence generations of artists up until the present.

Soon after his acceptance into the guild, Bruegel began a tour that took him through France and Italy, Switzerland and the Tyrol, possibly to gather landscape material for the printmaking shop of Hieronymus Cock, who began to publish engravings based on Bruegel's drawings from at least 1555 on. It is not easy to evaluate the importance of his Italian experience for Bruegel, because it came so early in his career and he absorbed its lessons so well, but it may be summed up as a new breadth of vision and a sense of the significance of the formal aspects of design. Van Mander writes that "on his journeys Bruegel did many views from nature so that it was said of him, when he traveled through the Alps, that he had swallowed all the mountains and rocks and spat them out again after his return onto his canvases and panels." Inspired by the profusion of rhythmic horizons, Bruegel created effective and powerful compositions that reflected the forces of nature and emphasized man's insignificance in the cosmos. His exacting observations of the s eep and grandeur of the Alps, such as the drawing of the Ticino Valley, *South of the St. Gotthard* (Figure 1),

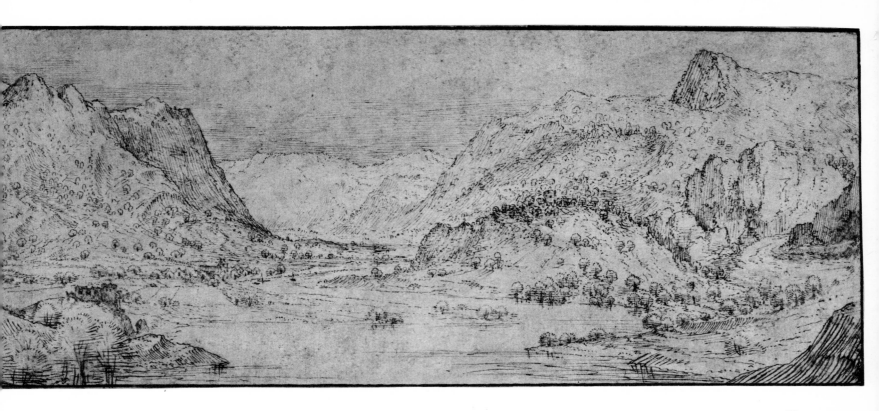

Figure 1.
Ticino Valley South of the St. Gotthard, (1554-1555)
drawing, 5″ x 13″
Kupferstichkabinett, Dresden

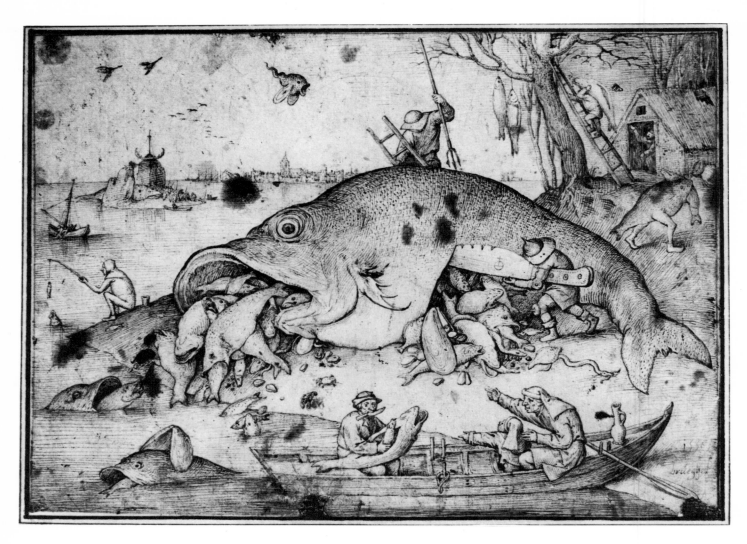

Figure 2.
Big Fish Eat Little Ones, (1556)
drawing, 8½″ x 11¾″
Albertina, Vienna

which influenced at least two of his later engravings and a painting, were to have a durable effect on future styles of landscape painting.

Quite abruptly in 1556, apparently with the encouragement of his lifelong friend and employer Hieronymus Cock, Bruegel put aside his interest in landscape to renovate the style of an earlier Brabantine artist, Hieronymus Bosch, who had died forty years before in 1516. Perhaps this new direction came as a result of a greater urgency to express a viewpoint on the vital and insistent problems of the day. Bosch's means of communication suggested an answer. His thoroughly didactic, moralistic genre paintings exemplify man's propensity for folly and wickedness, and his demonic fantasies, exploiting medieval bestiary symbolism, warned of punishments to come. Bruegel's drawing of 1556, *Big Fish Eat Little Ones* (Figure 2), for an engraving that seems to owe much of its inspiration to Bosch, illustrates a common proverb that appeared in innumerable controversial publications of the sixteenth century. Its literary antecedents go back as far as Hesiod (*Works and Days*, lines 277-279) and the Bible (Habakkuk 1:13-14). The imagery, which uses the analogous rapacity of sea creatures to "tell the infirmities of man" (Shakespeare's *Pericles, Prince of Tyre,* II, 1), can be seen as a general reflection of the uncertainty of the times, possibly the economic crisis of 1556 and 1557; but we should not forget that in Habakkuk it expresses criticism of governments that fail to protect the weak from the strong.

Bruegel's *Temptation of Saint Anthony* (Figure 3) adopts one of Bosch's favorite subjects and such characteristic motifs as hollow trees and craniums, fantastic edifices, and scurrying demons of all kinds, so that for some time it was considered to be by Bosch himself. But Bruegel was more than a facile imitator. His demons show more verve and a greater rotundity of form. Also, unlike Bosch who seems to be more concerned with the psychological aspects of the saint's inner struggle against man's inherent bestiality, there are indications in Bruegel's version that Saint Anthony's spiritual difficulties may stem from corruption within the Church—the hollow head inhabited by revelling monks, the rotting herring, and the fact that the banner decorated with Saint Anthony's cross is fastened to a barren tree.

In 1558 Bruegel began to find his own way, essentially freeing himself from dependence upon Bosch's visual imagination. From this point on he usually exploited recognizably literary subjects, ingeniously translating their message into pictorial drama that reveals his interest in the troubled world around him. Bosch, of course, had pioneered in moralistic genre painting, representing scenes based on everyday life to show man's foolishness; and during the first half of the sixteenth century depictions of the venality of tax collectors and usurers, or of the folly of senile lovers and other fools, had been popular in Antwerp. The success of satires such as the didactic poem *Ship of Fools* (1494) by the German Sebastian Brant, or the witty paradox *In Praise of Folly* (1511) by the Netherlander Desiderius Erasmus seems to have inspired many artists who sought to create visual counterparts for subjects from current literary works that already were familiar to a wide audience.

Bruegel's contribution was to widen the range and deepen the significance of moralistic genre through his exploitation of familiar literary themes, and to heighten the vitality and

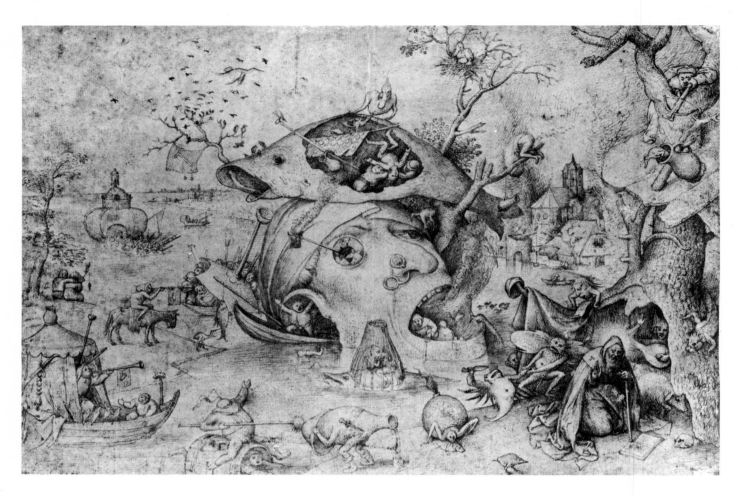

Figure 3.
Temptation of St. Anthony, (1556)
drawing, 8½″ x 12¾″
Ashmolean Museum, Oxford

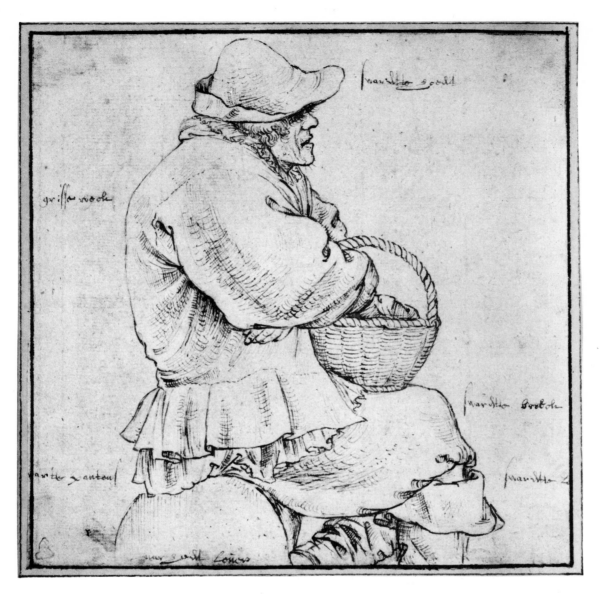

Figure 4.
Peasant With A Market Basket, (1566-1567)
drawing, 6⅛" x 5⅘"
Albertina, Vienna

current relevance of such subject matter by making it truer to life. He now utilized the invaluable experience gained from his many sketches *naer het leven,* that is, from life, such as the *Peasant with a Market Basket* (Figure 4). The 1558 drawing for the engraving *Elck,* or *Everyman* (Figure 5), is an excellent example of his new approach. By the use of a characteristic formula he contrasts two types of behavior and expresses the surprising view that neither one has merit. "Everyman" was the subject of a moralistic drama that had been published early in the century in Antwerp; and the theme of "Nobody" (in Latin, *Nemo*), which appears in the picture within the picture, was the subject of a number of popular satires, among them one by Ulrich von Hutten, a leading Lutheran propagandist. *Everyman* represents all of us who are so intent upon worldly things that we forget about the hereafter and its punishments for the ungodly. *Nobody* gains its humor from a play upon words ("Nobody is responsible," or as the picture tells us, "Nobody knows himself"), and the character Nemo, whose name means "Nobody," becomes the scapegoat who is blamed for the reprehensible acts that others commit while disclaiming their own responsibility. In this way Bruegel criticizes both the active people whose greed causes suffering for others, and the passive people who see evil committed but do nothing to stop it.

The pace of the troubles in the Netherlands quickened after 1559, when Philip II formed seventeen new bishoprics, appointing the "new men" himself in order to assure that there would be a stricter suppression of religious dissidence. This had a multiple effect; it alienated the nobility, who lost a chance to gain sinecures; it placed the incumbent abbots in a position subservient to the emperor's personal appointees; and most important, it made the Catholic Church a symbol of foreign rule. Bruegel's works during the years from 1559 until he moved to Brussels in 1563 suggest the heightening atmosphere of unrest, since most of them depict "battles" of one sort or another.

In 1556-57, Bruegel made a series of drawings for engravings of *The Seven Deadly Sins,* in which the imagery, bestiary symbolism, and fantasy owe a great deal to Bosch; but in 1559 and 1560 he completed a new series, *The Seven Virtues,* marking out a territory for himself and for art that had not been entered before. In the *Virtues* he reveals truly marvelous ingenuity in expressing a rather complex and philosophical idea that seems to have been based on the important and very popular moralistic treatise of Desiderius Erasmus, *Enchiridion,* or "The Shield of the Christian Warrior," which went through many editions after its original publication in 1503. In this profound book Erasmus is concerned with man's inability to distinguish between appearance and reality; and he suggests that we tend to confuse virtue with material show, when in reality true virtue is to be found only in spiritual devotion to Christian principles. As a reflection of Erasmus' study of the paradoxical contrast between lip service and actual behavior, in each of Bruegel's drawings for the series, such as in *Justice* (Figure 6), he distinguishes between the abstract meaning of Virtue (here personified by a female figure identified by such familiar attributes as the blindfold, the scales, and the sword), with surrounding scenes that show how badly mankind really be-

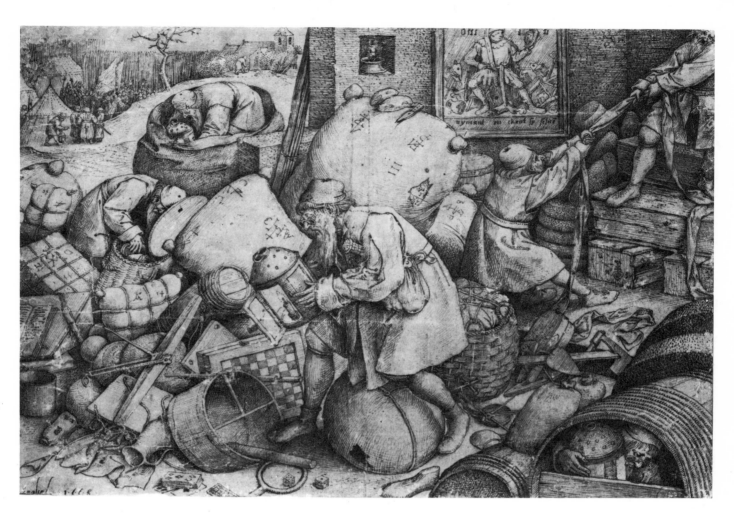

Figure 5.
Elck, or *Everyman.* (1558)
drawing, 8¼″ x 11½″
British Museum, London

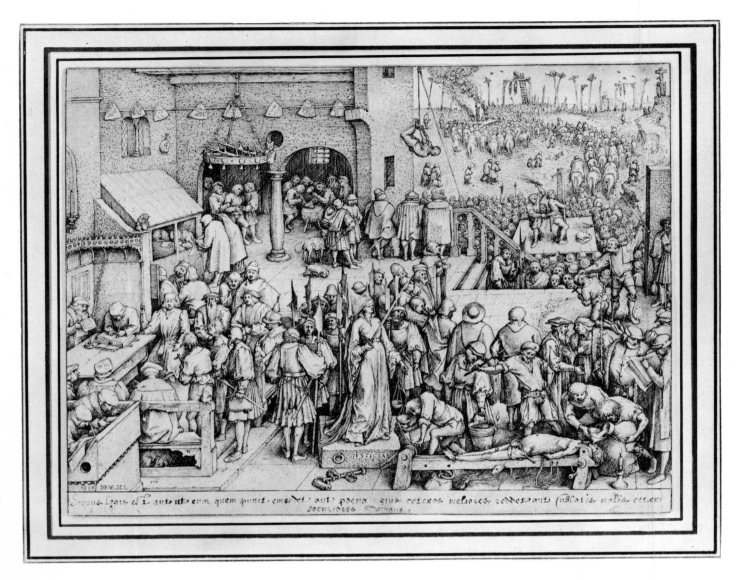

Figure 6.
Justice, (1559)
drawing, 8¾″ x 11⅜″
Bibliothèque Royale, Cabinet des Estampes
Brussels

haves. Even allowing for the public cruelty displayed in Bruegel's time, we should not mistake his preoccupation with torture and death as a sign of indifference towards suffering. On the contrary, he displays genuine concern. A man being condemned and another about to be beheaded pray before crosses, showing that even true Christians are ground under the heel of the courts. But the most revealing detail is in the upper right-hand corner, where, all but hidden among torture wheels and gallows, two figures stand (the Virgin Mary and John?) at the foot of a towering cross on which an all but invisible figure has been crucified. This reference to the Passion recalls an often repeated observation of Saint Bernard's, that all of the virtues were present when Christ was crucified except for one, and that was justice. There is every reason then to view Bruegel's drawing as a condemnation of the evil that man perpetrates in the name of justice.

Two interesting paintings, the *Netherlandish Proverbs* of 1559 (Figure 7) and *Children's Games* of 1560 (Figure 8), in retrospect seem to have provided Bruegel with an opportunity to exercise his innovative powers to the full. Both pictures are encyclopedic—containing some ninety-two proverbs and eighty games—which accounts for their complex character. Collecting proverbs was then a popular hobby of intellectuals, and Bruegel was quite inventive in assembling various maxims and translating them into a series of pictorial tableaux. It has also been suggested that his depiction of the playing children may symbolize the folly of adults who waste time in frivolities which do not deserve their attention. Both pictures are representative of the artist's earlier style, in which his compositions depend upon a sensitive arrangement of a multitude of figure groupings which, although distinctly separate, nevertheless work together to create a sense of unity.

However, it is the "battle" pictures of 1559-1562 that seem to give the principal flavor to this phase of the artist's career, and apparently they reflect the growing tension of his last years in Antwerp. The *Battle Between Carnival and Lent* of 1559 (Slide 2) makes use of a popular late medieval comic parody of chivalric battles, in which Lent was defeated, sent into exile, and allowed to return annually only during the Lenten period. But during Bruegel's lifetime the subject was no longer humorous, for those who failed to observe Lenten dietary practices or preached against them were turned over to the Inquisition for punishment as Lutherans. There is evidence in this painting that the battle is between Catholics and Lutherans, with Bruegel, characteristically, finding many things wrong on both sides.

The other "battle" pictures seem equally pertinent to the times. *The Fall of the Rebel Angels* (1562) appears to attack the temerity of the rebels, the *Suicide of Saul* rulers who persecute the godly. *Dulle Griet* (or *Mad Meg*) of 1561 or 1562 (Figure 9) is among the most interesting of this group, a kind of parody of Christ in Limbo. Mad Margaret, a legendary harridan in folklore who is so fierce that she terrorizes even hell, is shown as a huge female armed to the teeth, who charges across the field with a burden of spoils, an apparent victor over the forces of evil. She is supported by a marauding band of women who are looting on their own. Their adversaries in part are reminiscent of Bosch's demons, but seem to have allies in a force of knights who are readying a counterattack. The only figure com-

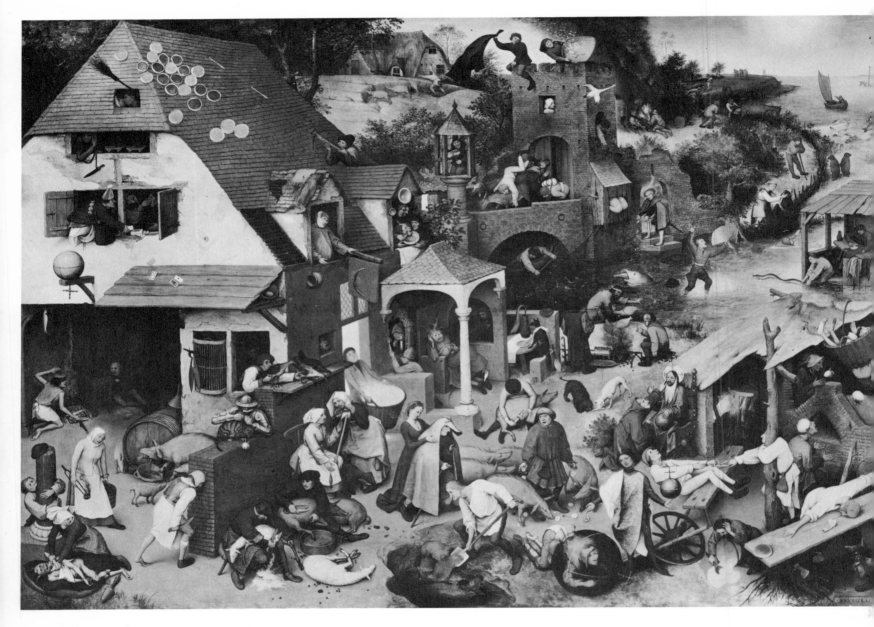

Figure 7.
Netherlandish Proverbs, (1559)
painting, 46″ x 64⅛″
Staatliche Museen, Berlin

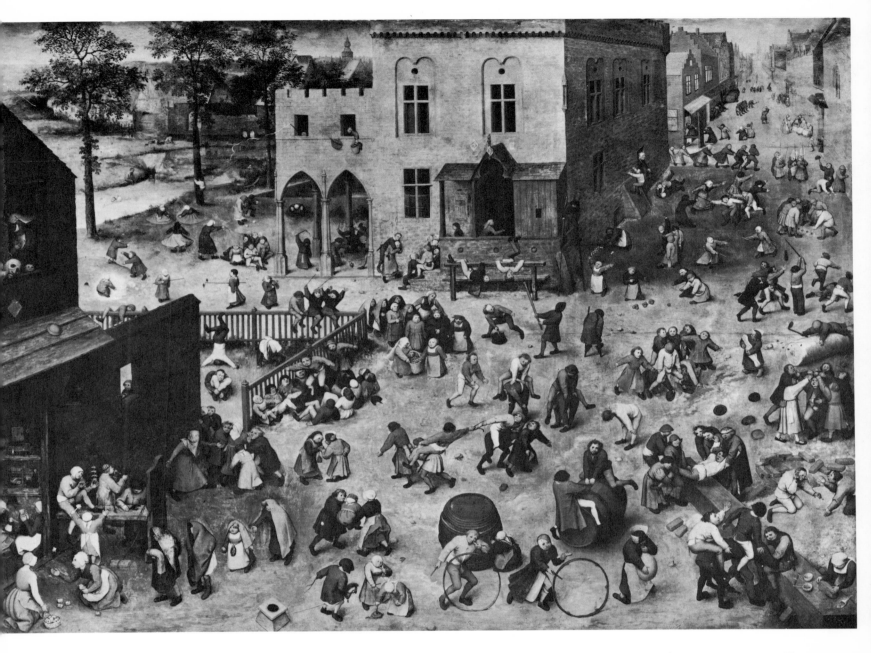

Figure 8.
Children's Games, (1560)
painting, 46½" x 63⅜"
Kunsthistorisches Museum, Vienna

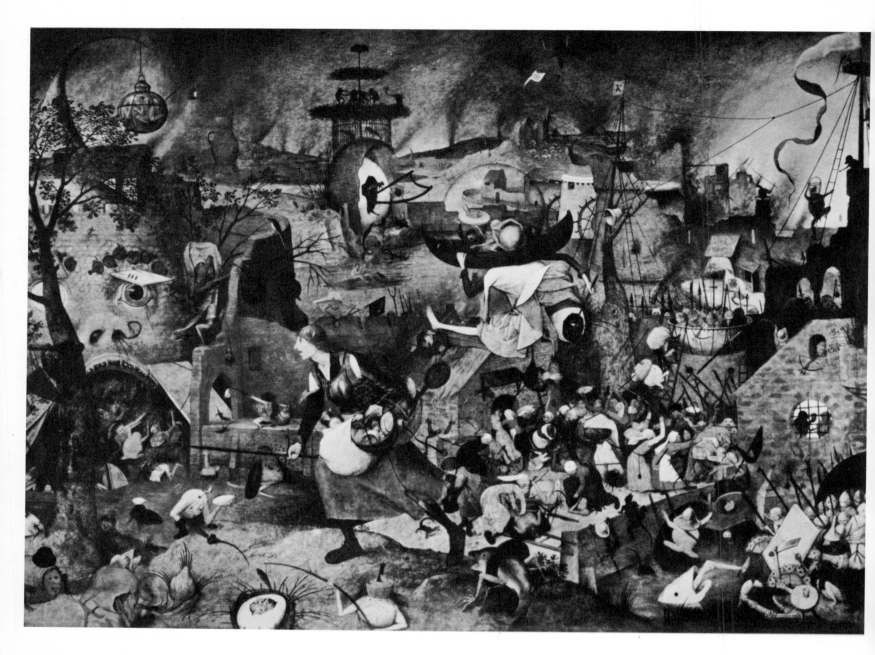

Figure 9.
Dulle Griet (Mad Meg), (1561)
painting, 45¼″ x 63⅜″
Musée Mayer van den Bergh, Antwerp

parable in size to Margaret is that of a man who skulks on a roof under a boat full of invidious creatures, while he ladles out money from his egg-like behind to distract the rampaging women. The traditional folklore about Mad Margaret does not prepare us for this exposition of violence and greed, suggesting that Bruegel embroidered a commentary on the times within the facade of the folk tale. The acquisitive natures of Philip II's governors, which were a current scandal, might account for certain details in the picture. The regent Margaret of Parma, who was praised for her masculine aggressiveness by her admirer the historian Famianus Strade, wrote glowing letters to Philip II on the possibilities for becoming wealthy at the expense of the Netherlanders. Her intense rivalry with Cardinal Granvelle and his council of state (the skulking man and the boat on his back?) led to a bitter exchange of charges and countercharges of looting the Netherlands to fill their own pockets. Thus Bruegel in this case alters folklore in a way that is most suggestive, yet sufficiently evasive to conceal his true meaning from all but those who might be in on the secret.

The *Triumph of Death* (Slide 3), probably painted in 1562, represents the most pessimistic battle of all, in which death is the only victor. People of all stations in life, engaging in all of the sins, fall victim to death's unremitting horde, as they do in the traditional treatments of the Italian *Triumph of Death* and the North European *Dance of Death,* which appear in literature and art. Bruegel's decision to couch the old subject in military terms suggests that he may have been thinking of the pacifistic ideas formulated by Erasmus and other humanists of the period, and expressing his fear of the looming religious-political conflict.

Some scholars believe that when Bruegel forsook Antwerp in 1563 and moved to Brussels, the capital city, he proved that he was indifferent to political and religious controversy and that he had a clear conscience about his art. We have seen that on the contrary he was far from indifferent about events, which suggests that we should seek for a more positive explanation for his move. He had just married Mayken, and as part of the marriage settlement he had been given a fine house that is still standing in Brussels, where it has been converted into a museum. His new responsibilities, for which he still showed an awareness in his final hours when he burned his more dangerous drawings, together with his growing pessimism and dread about the heightening tension in Antwerp, must have left no question in his mind about the desirability of the change. Antwerp had become a haven for dissidents against the Empire. Much of the Protestant literature in Europe was published there, and Philip II's agitation was increasing. Moreover, in 1561, two years before Bruegel left Antwerp, its artists' guild had joined forces with the Guild of Rhetoricians to organize the famous *Landjuweel,* a national festival of drama and belles-lettres. Bolstered by a feeling of safety in numbers, the participants unleashed a program of such subversive propaganda that it would only be a matter of time before the Emperor struck back. As a matter of fact, he showed such a long memory that in 1567 when the punitive forces of the Duke of Alva entered the city, the Burgomaster, Antony van Straelen, who had promoted the *Landjuweel,*

was one of the first to be executed. Many of Bruegel's patrons and associates belonged to the two guilds that had participated in the festival, so that he had good reasons for leaving a city that was courting disaster.

Bruegel's move to Brussels was accompanied by changes in his style and subject matter. His work became more unified and simpler in composition and his figures fewer and larger. His seascape the *View of Naples* (Slide 4) is transitional in this respect, altering the details of his old on-the-spot sketches to create a circular composition of land, sea, and sky.

From 1563 until the arrival of the Duke of Alva in 1567 he turned again to Old and New Testament subjects, which seemed peculiarly appropriate as comments on current events, particularly since he used settings and costumes that were part of his everyday world.

In 1563, for example, Bruegel seems to have painted at least two versions of the *Tower of Babel,* a subject that had interested him early in his career. The dated, larger version in the Kunsthistorisches Museum in Vienna (Slide 5) could have been painted just before Bruegel left Antwerp, since it was listed in the inventory of Niclaes Jonghelinck's collection in 1556. Traditionally, its story from Genesis 10:8-9 and 11:1-9 was understood as a warning to kings not to forget that their power was subservient to God's; but we should remember that in the sixteenth century Protestant theologians compared Nimrod, who built the tower, to the Pope, and saw in Nimrod's overthrow a portent of the end of Catholic power.

Bruegel's painting *The Procession to Calvary* of 1564 (Slide 6), which emphasizes the indifference of mankind to Christ's sacrifice, by means of the modern dress of its participants, recalls that only a few years later, in 1567, Philippe Marnix, a key figure in the revolt against the Empire and a leading Protestant polemicist, was to write that if Christ were to return and preach his own doctrines in these times, He would be declared a heretic and crucified again.

The *Adoration of Kings* in the National Gallery in London (Figure 10), also dated 1564, may be the earliest of Bruegel's paintings to feature a close-up composition with monumental figures. As such, the painting gives the artist an opportunity to display a wide range of types and their varied reactions to the momentous event. The large, staring, round eyes of the soldiers and some of the onlookers on the left side of the painting are quite reminiscent of the style of the Florentine Mannerists Pontormo and Il Rosso in the 1520s; and according to the physiognomic treatises of the Middle Ages it was a characteristic expressing awe and amazement. In addition, the elongated figures and the subordination of spatial illusionism to dramatic intensity that Bruegel practiced here, and in other religious pictures early in the 1560s, also suggest Italian influence. It is also interesting to see intimations of an evil presence creep into his portrayals, particularly in his characterizations of the kings.

In the same year, 1564, Bruegel created an extraordinary drawing concerned with the confrontation between Saint James the Minor and the magician Hermogenes in *The Fall of the Magician* (Figure 11). In *The Golden Legends* of Jacobus de Voragine, a thirteenth-

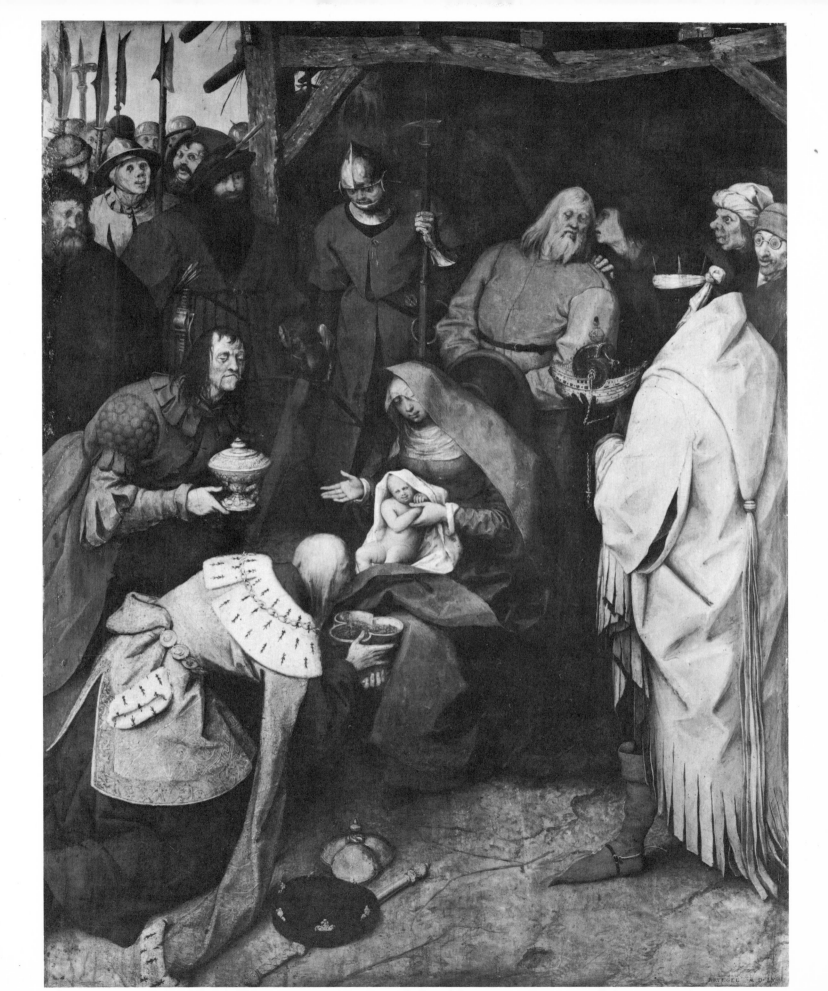

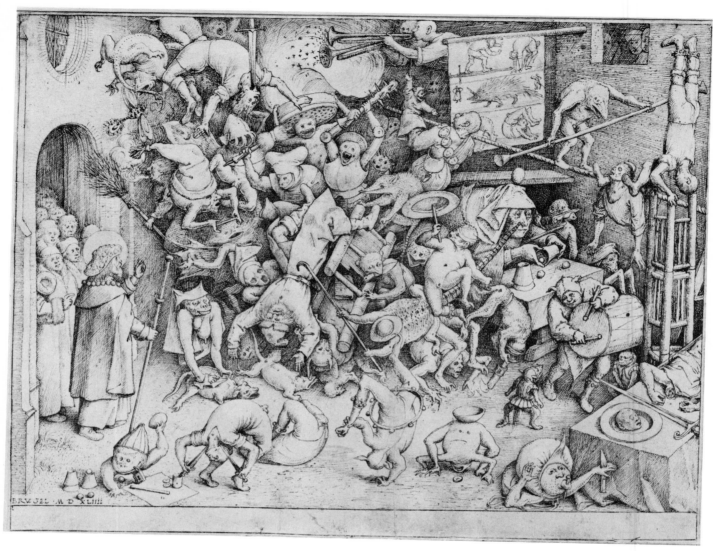

Figure 11.
Fall of the Magician, (1564)
drawing, 8¾″ x 11½″
Rijksmuseum, Amsterdam

century collection of stories about the saints which was a primary source for many works of art, the incident is used to show Saint James' tolerance in preventing the magician's enthralled spirits from exacting vengeance once they had been released. Bruegel shows just the opposite in characterizing Saint James, who as Saint James of Compostella was of exceptional importance to Catholic Spain, as a seeker of vengeance. It is also interesting that the largest figure is neither of the two protagonists, but an immense man wearing a monkish cowl who is playing a "shell game," offering the clue that things are not quite what they seem to be. The presence of other entertainers, acrobats and puppeteers, also increases the suggestion that we are being misled in some way. In addition, there is an underlying theme of martyrdom: the head on a plate is a reference to Saint John the Baptist, beheaded by Herod at Salome's request; and in the same *Golden Legends,* where this story appears, Saint Sebastian is martyred by being shot so full of arrows that he resembles a hedgehog, an animal that appears on the chart behind the cowled man. Finally, we notice that as Hermogenes is toppled from his chair by the vengeful spirits, a book, perhaps the Scriptures, falls with him. All of this artistic sleight-of-hand, revising the character of the Spanish patron saint and mingling references to martyrdom and skullduggery, makes one wonder if Bruegel had not heard of the sensational event that had taken place in Antwerp in the same year, when the popular Protestant minister Fabritius (De Smet) was burned at the stake as a heretic, and an uprising of his followers who tried to save him from the fiery death was thwarted by the Captain of the Guards, who ran him through with his sword at the last moment.

The engraving *The Parable of the Good Shepherd* (Figure 12), although dated 1565, was probably designed in 1564, a year of unusual tension that reached a climax when Philip II, ignoring the agreement he had concluded with an embassy of Netherlandish nobility, dispatched a decree to the colonies which made it tantamount to treason to hinder the Inquisition in any way. This decision on Philip's part amounted almost to a declaration of war, since, because of the temper of opinion in the Netherlands, it could only be enforced by sending troops. Perhaps it was this situation that inspired Bruegel to change the usual emphasis given to the Parable, minimizing the contrast between the good and bad shepherds and concentrating on the passages from *John* 10:1-16 which tell us that

> He that entereth not by the door into the sheepfold, but
> climbeth up some other way, the same is a thief and a robber . . .
> The thief cometh not, but for to steal, and to kill, and to
> destroy . . .

In the *Acts of Thomas* in the Apocrypha this imagery was used as a reference to persecutors of Christians, and it was adapted by Protestant polemicists in the sixteenth century to describe the "papal wolves" who descended from Romulus, the founder of Rome, who was reared by a wolf.

In 1566 and 1567 Bruegel continued to depict scenes from the Passion of Christ, giving

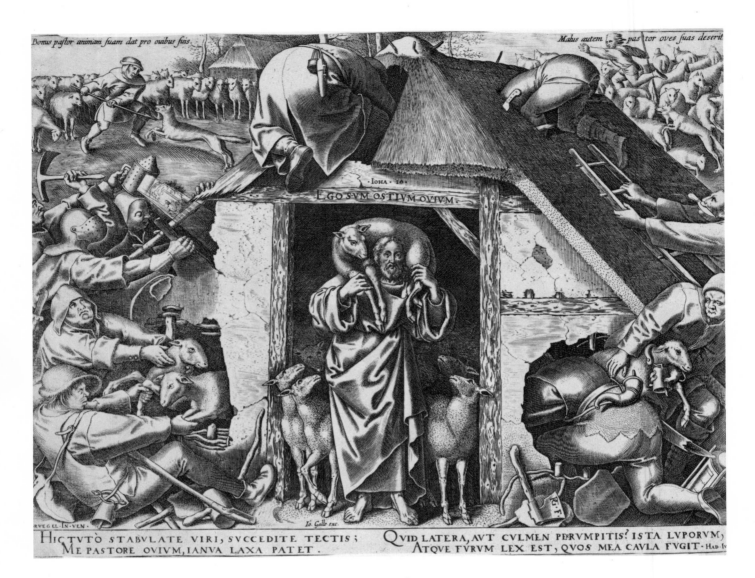

Figure 12.
Parable of the Good Shepherd, (1566)
engraving, 8¾″ x 11⅗″
The Metropolitan Museum of Art
Harris Brisbane Dick Fund, 1953

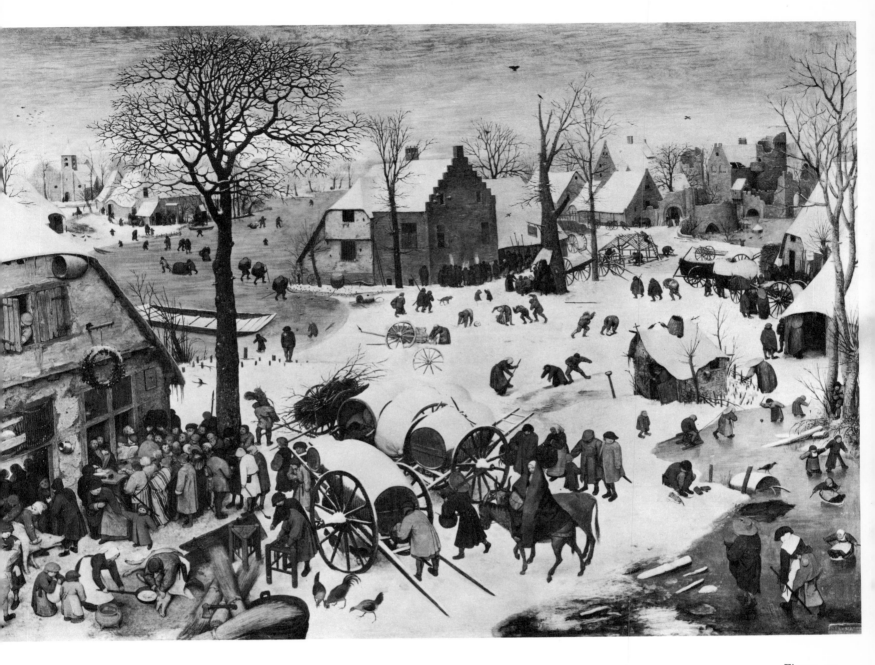

Figure 13.
Numbering at Bethlehem, (1566)
painting, 45⅝″ x 64¾″
Musée Royaux des Beaux-Arts, Brussels

them new relevance by using contemporary settings and actors. To this period belong the *Massacre of the Innocents,* the *Numbering at Bethlehem,* and the *Adoration in the Snow.*

The *Numbering at Bethlehem* of 1566 (Figure 13) shows the arrival of the Holy Family at the inn (Luke 2:1-5), where the people are reporting for the census. Because the setting is an ordinary village in winter, one's first impression is that we are looking at genre rather than religious painting. The same is true of the *Adoration of Magi in the Snow* (Figure 14), where even the presence of the kings and their shivering retinues hardly seems to disrupt the normal activities of a Lowland village.

The *Massacre of the Innocents,* which bears no date, exists in two versions. The one at Hampton Court in the Queen's Collection (Figure 15) is sharper in its characterizations and definition, but it was overpainted in the seventeenth century to disguise the fact that the soldiers are butchering children. The copy in Vienna's Kunsthistorisches Museum (Slide 7), although it seems to be less polished in technique, gives a better idea of the original subject matter. Two details in the painting, a gaily appareled horseman who wears the emperor's insignia, and a dour black knight with a long beard who observed the massacre at the head of a company of armored cavalry, leave one with the impression that the painting was inspired by the new wave of religious persecution instituted by the Duke of Alva, the "Black Duke," upon his arrival in 1567, when the picture might have been painted.

Although Bruegel's *Sermon of Saint John the Baptist* in Budapest (Slide 8) treats a traditional subject, certain details which verge on satire and the fact that it was painted in 1566 suggest that it was a reference to the growth of the Calvinist movement, which, in the year in which Bruegel painted this picture, encouraged its followers to dare to hold open-air meetings under the protection of their own militia.

The same timeliness holds for Bruegel's *Conversion of Saint Paul* (Slide 9), which bears the date 1567 and contains several details, including its unusual Alpine setting, that seem to refer to the coming of the Duke of Alva's punitive mission. It is possible that Bruegel could have heard that the Duke suffered from the gout and tertian ague while raising his army of 10,000 in Asti, and that this information suggested a comparison with Saint Paul, who as Saul was struck with blindness when he led an army against the Christians (Acts 9:1-22).

In 1565 Bruegel returned to his earliest interest, painting a series of landscapes depicting the seasons for his old friend and patron, Niclaes Jonghelinck of Antwerp. In these landscapes we find a change in Bruegel's technique. He seems to have worked more rapidly and more loosely than earlier, in some passages foreshadowing the freer, more impressionistic technique of Baroque artists like Rubens. This spontaneity continues throughout the last few years of his career. There is still controversy over the number of paintings that were in the series, and at present only five are extant. The *Hunters in the Snow* in Vienna (Slide 10) apparently represents December and January. The skaters enjoying themselves on the frozen lakes can be contrasted with the industrious group singeing a pig; and it may

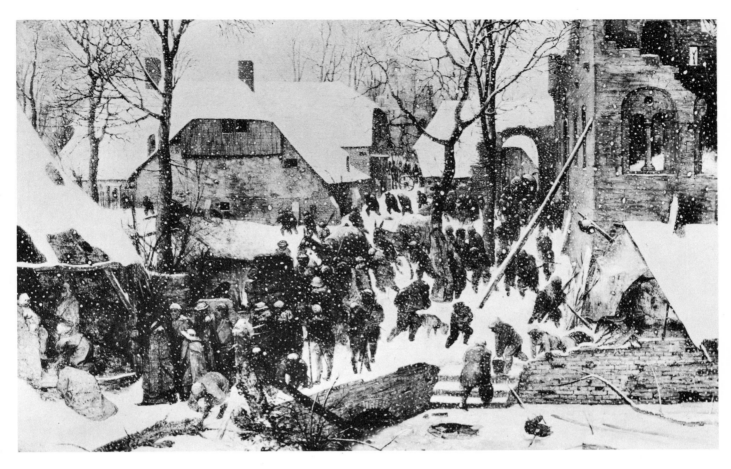

Figure 14.
Adoration of the Magi in the Snow, (1567)
painting, 13¾″ x 21⅝″
Collection Oskar Reinhart am Römerholz, Winterthur

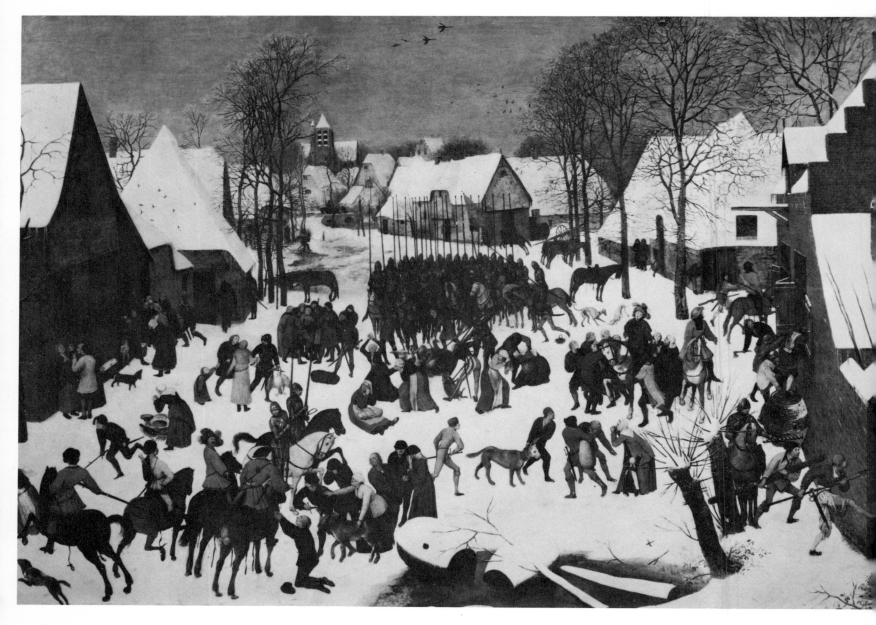

Figure 15.
Massacre of the Innocents
painting, 43″ x 61″
Hampton Court, Copyright reserved

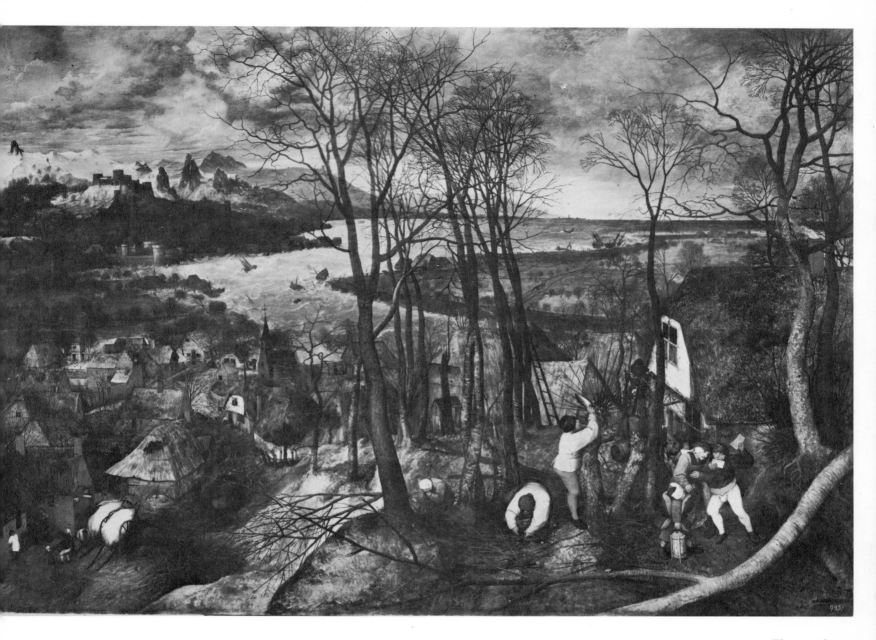

Figure 16.
The Gloomy Day, (1565)
painting, 46½" x 64⅛"
Kunsthistorisches Museum, Vienna

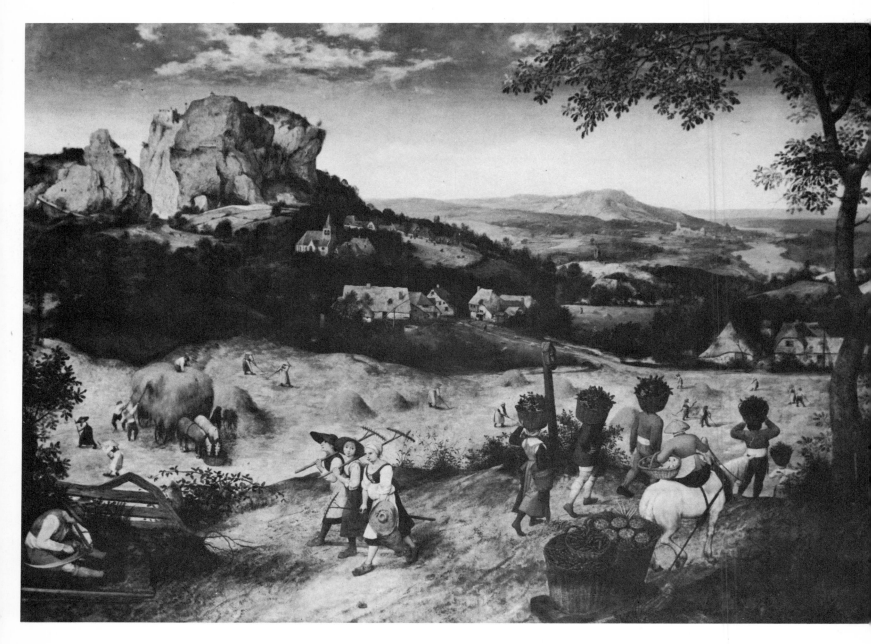

Figure 17.
Haymaking, (c. 1565)
painting, 46″ x 63⅜″
National Gallery, Prague

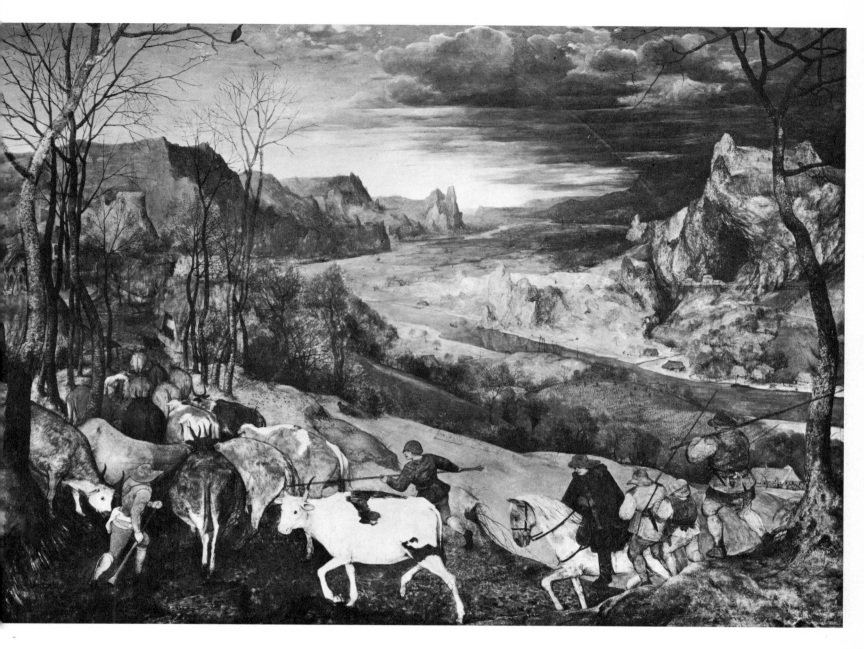

Figure 18.
Return of the Herd, (1565)
painting, 46″ x 62⅝″
Kunsthistorisches Museum, Vienna

be that Bruegel agreed with Sebastian Brant, who in his *Ship of Fools* expressed the view that hunting was a foolish and wasteful activity. February and March may be represented by another painting in the Kunsthistorisches Museum, *The Gloomy Day* (Figure 16), in which woodsmen at the right are pruning willow trees. Next to the working men there is a reference to Carnival and its follies. A woman holds the hand of a child who carries a lantern. The child wears a Carnival hat, and he is padded before and behind with pillows. The woman is linked arm-in-arm with a man who munches on Carnival waffles. *Haymaking* in the National Gallery in Prague (Figure 17) seems to represent June and July; and the *Harvesters,* in the Metropolitan Museum of New York (Slide 11), August and September. The fifth extant painting, *The Return of the Herd* in Vienna (Figure 18), showing cattle coming down from the mountains, is an unusual motif for such a series, but Martin van Valckenborch, a landscapist active in Antwerp between 1564 and 1572 who was often influenced by Bruegel, used it in his own series to represent November.

The third type of subject that interested Bruegel enough during his Brussels period to lead to the creation of a related group of pictures revolves around the vices of gluttony and sensuality. In these moralistic genre paintings, which in part are responsible for his reputation as a "droll" artist, he shows how the marriage sacrament and religious observances such as the kermess, or saint's festival, became excuses for gluttony, drinking, dancing, and other excesses. In his engraving *The Wise and Foolish Virgins* (Figure 19)—taken from the parable of the virgins in *Matthew* 25:1-13—Bruegel characterizes the foolish virgins as those who dance to bagpipe music, in contrast to those who sew and spin, although there is no mention of these activities in the Biblical text. Further in the print, *The Marriage Dance* (Figure 20), which is a pastiche of Bruegel's motifs, the accompanying verses intimate that the bride is not dancing only because she has become pregnant as a result of the lasciviousness brought on by previous dancing. Apparently, then, Bruegel's views of such goings-on coincided with those of other sixteenth-century moralists such as Sebastian Brant, Cornelius Agrippa, and John Calvin. With this in mind, the purpose of such paintings as the *Wedding Dance in the Open Air* of 1566 (Slide 12) becomes somewhat clearer, showing in unmistakable terms that the sanctity of marriage has become confused with man's pursuit of pleasure. *The Wedding Banquet* in the Kunsthistorisches Museum in Vienna (Slide 13), probably painted in 1567, shows the beginning of the feast that will precede the dancing to bagpipe music, thus placing the emphasis on the gluttony and the pride (the peacock feather) that have overshadowed the religious significance of marriage. In the same museum we find the rowdy *Peasant Dance* of perhaps the same year (Slide 14), in which the ground almost seems to shake under the tread of the massive dancers, who ostensibly are celebrating a religious holiday. There is an indication, in the activities of the figures behind the bagpiper, that all of the Seven Deadly Vices are unleashed at such kermesses, and the children are about to follow in the footsteps of their elders. Perhaps Bruegel's last use of the dancing motif is in the painting of 1568 called *The Magpie on*

Figure 19.
Parable of the Wise and Foolish Virgins
print, 8¾″ x 11⅝″
The Metropolitan Museum of Art
Harris Brisbane Dick Fund, 1928

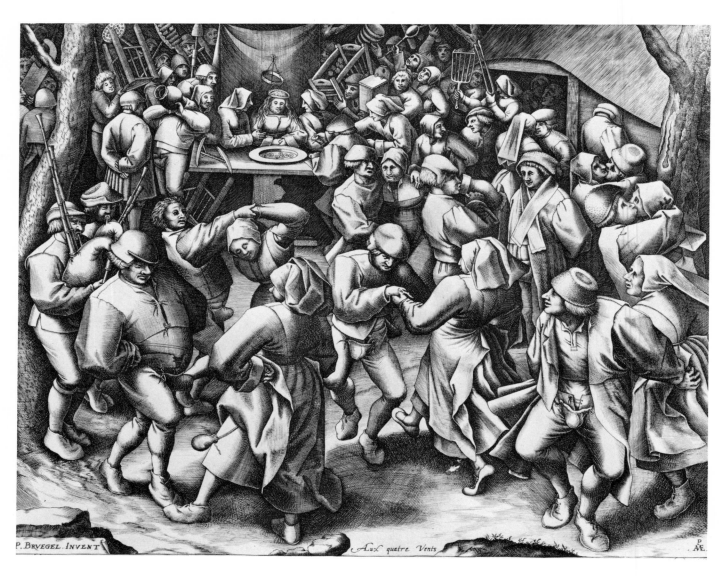

Figure 20.
The Marriage Dance
print, 14¾″ x 16⅗″
The Metropolitan Museum of Art
Harris Brisbane Dick Fund, 1928

the Gallows (Slide 15), which the artist bequeathed to his wife. Here, apparently, the way of the gallows is contrasted to the way of the cross, just as the dancers and the gluttons are contrasted with the churchgoers and the industrious people who are seen in the distance.

We have saved for our last consideration a group of pictures in which Bruegel's meaning is most elusive. The fact that they date from his last active years, when the Duke of Alva's presence was most apparent, may explain Bruegel's lack of candor. The *Land of Cockaigne* (Slide 16) belongs to this group and uses an old traditional theme that criticizes mankind in general without alienating anyone in particular. It illustrates the age-old dream of an earthly paradise where as *Ship of Fools* tells us, you wait without having to do anything, "until a roast fowl slips to earth and nestles 'twixt your lips."

The Parable of the Blind of 1568 (Slide 17) illustrates an old literary theme based upon *Matthew* 15:14 ("And if the blind shall lead the blind, both shall fall into the ditch"). His group includes representatives of various estates in life who are led away from the Church (in the background) by listening to others.

The various levels of society are also alluded to in *The Cripples* of 1568 (Slide 18), which makes a savage commentary using their obvious physical limitations as metaphors of mankind. Bits of costume suggest the military, priesthood, nobility, and so forth; while the foxtails with which they are tagged were often used to symbolize deceitfulness or slander, and were the emblems worn by lepers during the Carnival season.

The Peasant and the Bird-Nester (Slide 19) combines two themes reminiscent of the "Everyman" and "Nobody" characters used by Bruegel in his earlier engraving, *Elck* (Figure 5). The actively aggressive man is climbing a tree to steal birds eggs, and he has lost his hat and almost his grip on the tree in his eagerness. The man striding towards us, who points mockingly at the other's precarious situation, is almost about to fall into a muddy ditch, like the men in *The Parable of the Blind.*

The Misanthrope (Slide 20), a painting dated 1568, reads like Bruegel's epitaph, carrying an inscription which says, "I am going into mourning because the world is so treacherous." That the subject was of some significance for Bruegel is attested to by a second version (Figure 21), an engraving that is part of a series of twelve Flemish proverbs. In neither case does the inscription have the usual aphoristic ring of a proverb, and Bruegel's exact meaning is still somewhat obscure in spite of it. Sharing the esoteric quality of so many of the artist's late works, the painting reveals the frustrating conflict that he must have faced towards the end, when he could neither abandon the didactic means of expression that he had so laboriously developed, nor dare to express his ideas too openly.

In the final analysis there is a remarkable consistency in Bruegel's message. What he seems to be saying is that the world is cruel and dangerous because man has made it so; but that those who wash their hands of responsibility like Pilate are not less guilty. He seems to indicate that if all men of good will were to act in unison, the world would be a better place.

As a representative intellectual of the sixteenth century, Bruegel belongs, along with Erasmus, Brant, and Agrippa, among those who were concerned with the spiritual illness of the proto-modern era, when religious fanaticism, Machiavellian awareness of political power, and unrestricted financial and mercantile predaciousness unleashed forces for chaos and suffering that stirred all sensitive men to raise their voices, pens, or paintbrushes in dismay.

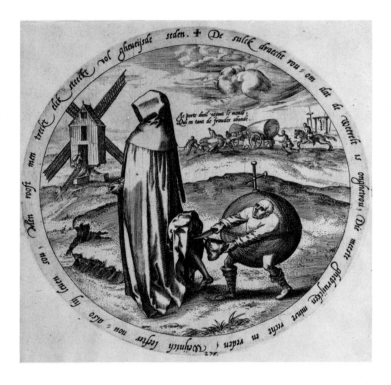

Figure 21.
The Misanthrope
print, 3⅜″ x 3⅜″
The Metropolitan Museum of Art
Harris Brisbane Dick Fund, 1946

COMMENTARY ON THE SLIDES

1. THE FALL OF ICARUS (c. 1555), tempera worked over with oil transferred from panel to canvas, 29″ x 44⅛″
Musées Royaux des Beaux-Arts, Brussels

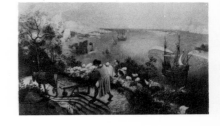

Although he rarely turned to classical mythology, the story of Icarus, whose ambition to fly up to the sun led to his own destruction, apparently suited Bruegel's moralistic nature, since there are at least four examples of the subject among his works. In addition to this painting in the Brussels Museum there is a smaller painted version in the D. M. van Buuren Collection (New York and Brussels), an engraving printed in 1553, and Icarus appears unexpectedly above a Spanish man-of-war in the suite of engravings, *Vessels of the Seas,* which Hieronymus Cock published in the 1560s. In the van Buuren example, Icarus' father, Dedalus, who does not appear in our painting, hovers above the rocky island beyond the plowman and provides a reason for the shepherd's upward glance. In both paintings Icarus' fall to his death goes unheeded, as life goes on. Even the corpse of an old man in the bushes at the left does not stop the work of the plowman.

Although there is some controversy about the authenticity of both paintings because of their present condition, there is little doubt that they are representative of the artist's early landscape style. While he still finds it necessary to provide an anecdotal, narrative element as an excuse for the study of nature, there is an emerging sense of unity in combining disparate elements. A series of curving arcs—in the plowman's furrows, the movements of the sails, landscape forms, and even the shapes of the figures—provides a dominant and consistent stylistic motif.

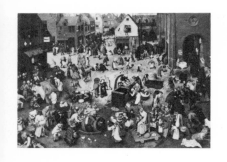

2. THE BATTLE BETWEEN CARNIVAL AND LENT (1559), tempera on panel 46½" x 66¾", Kunsthistorisches Museum, Vienna

It is interesting to conjecture why Bruegel should have chosen to depict this subject in the way that he did at this point in his career, for in his time the observance of Lent had become a crucial point of contention between Catholics and Protestants. Bruegel had more than the traditionally comic aspects of Carnival in mind, for he certainly shows little respect for either lovers or opponents of Carnival. The Lutherans, who did not observe Lent, are portrayed on the left as licentious gluttons, gamblers, and dancers who waste their time watching entertainers and profane dramas. But the Catholics are not spared either. Some ignore the Sabbath to earn money or do chores. Others, who have worshipped the material aspects of religion such as relics of the saints, turn immediately thereafter to frivolous games. Even their ostentatious charity is suspect in an age when professional beggars were regarded as a menace to society. Two corpses, one trundled in a cart by an old woman, and another lying in the foreground, swathed in a shroud, suggest that if it were not for the fear of death no one would bother to be charitable or even religious. Since the pictorial composition and proportions of this painting are rather close to both *The Netherlandish Proverbs* and *Children's Games* (Figures 7 and 8), we rather suspect, because he seems impartial towards the "combatants," that Bruegel has expanded his attack to show that some men are as foolish in their observance of religion as others are in turning away from it. A more successful composition than the other two pictures, with a tighter arrangement of forms integrated in a powerful circular movement, this painting also has a great deal of interest from a historical and sociological viewpoint, telling us something about the street scenes to be found in the artist's lifetime—the processions, the wandering players, the markets, and the beggars.

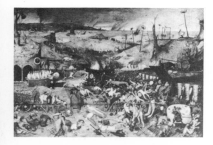

3. THE TRIUMPH OF DEATH (c. 1562), tempera on panel 46" x 63¾", Prado, Madrid

In illustrating the theme of the crushing inevitability of death, Bruegel universalizes his meaning, demonstrating that all kinds of people, including kings and cardinals, must die; even an army fighting in massive phalanx crumbles at death's onslaught. He also makes the point that the wages of sin is death for the licentious, the greedy, and the quarrelsome. Since in this grim vision there is no escape from the Day of Judgment, the moralistic implications are reminiscent of Erasmus' declaration that we should spur our own faith by meditating upon death all of our lives.

The overall composition lacks a dominant structural pattern and has no prominent focal point, but it features many powerful details and groupings, particularly in the foreground.

If there is a unifying device, it is in the repetition of discs of various size—the wheels of the death wagon, the table top, barrel openings, shields, and execution wheels—which are spotted all over the composition in a seemingly haphazard manner. Most of Bruegel's early paintings are made up of assembled compilations of related motifs in which he arranged groups of figures to create rhythms and other interrelationships. This might have suggested a similar treatment for the more abstract shape of the circle. Here, with unparalleled originality, Bruegel seems to foreshadow the abstract art of the future.

4. VIEW OF NAPLES (c. 1562-1563), panel, 15⅝″ x 27⅜″
Galleria Doria, Rome

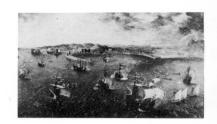

Bruegel was to have a lasting influence upon the seascape and landscape painters of Northern Europe. *View of Naples* is but one of several seascapes still extant. Quite early in his career he painted a seascape with a burning town, and his earliest signed and dated painting, *Christ Appearing to the Apostles at the Sea of Tiberias* (1553), is largely a view of ships and water. There is also a series of engravings of ships at sea, published by Cock in the 1560s, and one of his last paintings was the unfinished *Storm at Sea* in Vienna, which shows that his interest in painting ships and water continued throughout his life.

The *View of Naples* apparently was based upon drawings that had been made ten years earlier when in Italy, and it includes a number of landmarks that still exist. However, Bruegel has transformed its rectangular harbor jetty into a circular one that echoes the curving lines of the shore, the arcs of clouds and wavelets, and the forms of the sailing ships that are scattered in a wavering curvilinear arrangement. His means of imposing order upon nature, of unifying the casual and the controlled in panoramas governed by both a calculated placement of separate elements and a search for a pattern of continuous linear linkage, was to strongly impress later artists.

5. TOWER OF BABEL (1563), panel, 44⅞″ x 61″
Kunsthistorisches Museum, Vienna

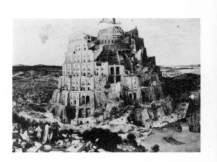

This picture was probably painted for Bruegel's patron, Niclaes Jonghelinck of Antwerp, and later came into the possession of Rudolf II, the monarch responsible for Vienna's outstanding collection of the artist's works. Bruegel was much taken with this subject, which reflects on the vanity of human endeavor, and particularly on the punishment that comes

to the vain. Earlier, during his stay in Rome, he had painted the same subject for his friend the miniaturist Giulio Clovia, and a smaller version without Nimrod is now in the Boymans-van Beuningen Museum in Rotterdam.

The crumbling tower, it has been noticed, bears a certain resemblance to the Colosseum and other Roman ruins, which for Bruegel's contemporaries symbolized the destruction of the pagan world and retribution for the abuses of the once-powerful Caesars. Bruegel had visited these ruins many years earlier and probably was reminded of them by Hieronymous Cock's engravings; but his reference to Rome and Caesars in this case seems suspiciously like a warning to Philip II of Spain, the Holy Roman Emperor and then-current embodiment of the ancient Caesars. As always, Bruegel's exactness in attending to details gives the viewer a clear insight into the engineering and building methods of his day; and with straightfaced humor he shows how the emperor's visit to the stonemasons causes an obsequious disruption of their activities. The composition is almost completely subservient to the form of the tower, but no detail that contributes to the versimilitude of the scene has been neglected, including the vast shadow cast by the edifice, or the impressionistic delineation of distant figures and foliage.

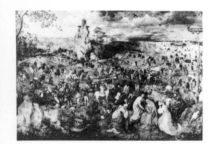

6. PROCESSION TO CALVARY (1564), panel, 48⅞" x 66⅞"
Kunsthistorisches Museum, Vienna

Listed among the possessions of Niclaes Jonghelinck, this is probably Bruegel's largest known painting, and the only one for which preparatory figure studies survive (*Two Men Seen from the Back,* Boymans-van Beuningen Museum, Rotterdam). The subject was a traditional one, and Bruegel followed earlier formats such as those used by Jan van Amstel (The Brunswick Master), Pieter Aertsen, and Herri met de Bles. He made significant changes, however, which give the subject new poignancy and relevance. Christ is almost lost in the center of the composition as he stumbles under the weight of the cross. Simon of Cyrene struggles with the soldiers who are trying to make him help Christ to bear the cross, and his wife, who wears a rosary and cross in outward show of piety, helps her husband to resist participation in this act of mercy. In the distance a curious crowd assembles in a circle in anticipation of the gruesome spectacle; closer at hand, where reactions are more easily discernible, we can see only callous indifference or eager curiosity. Thus, in everyday terms, noted down to the dripping wheels of the cart that carries the thieves, we have a profound reflection on the failure of Christianity to create a sense of responsible brotherhood. Bruegel seems to be saying quite obviously that if man were to follow Christ all the way, he could not ignore the significance of His sacrifice and acquiesce to the cruelties which then were so rampant throughout the land. Only the mourners in the foreground, gracefully and manneristically elongated, and joined in almost a separate composition, con-

trast with the brutal, unfeeling mass of humanity around them. One of the striking features of the composition is the wavering line of red-coated figures who move across the middle distance towards the place of execution, creating a casual but effective sense of unity.

7. THE MASSACRE OF THE INNOCENTS (c. 1567), panel, 45⅝" x 63"
Kunsthistorisches Museum, Vienna

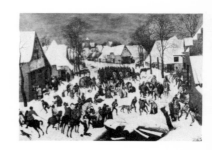

Although some art historians have dated this picture as early as 1565, the presence of the sinister commander in black and the double-eagle insignia worn by the shrugging courtier at the right could well indicate a reference to the arrival of the "Black Duke," the Duke of Alva, in 1567, making the later date more probable.

The evidence of X-rays suggests that this painting of the subject may be a workshop copy touched up by the master. The slightly smaller painting in Hampton Court (Figure 15), overpainted during the seventeenth-century to eliminate the slaughter of the children and badly restored in major areas, is more likely Bruegel's original version. Arguments that Bruegel had no ulterior purpose in mind when he showed this butchery being committed in a contemporary village by Imperial troops and mercenaries seem far from convincing.

8. THE SERMON OF SAINT JOHN THE BAPTIST (1566), oil on panel
37⅜" x 63¼", Museum of Fine Arts, Budapest, Batthyany Collection

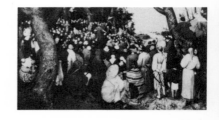

This is another instance in which Bruegel seems to have given contemporary significance to Biblical material. Not only does the date, 1566, have particular relevance as the momentous year in which the Calvinists showed their strength and defiance by holding the first open-air religious meetings since the Anabaptists were massacred thirty years before in their stronghold at Münster, but the crowd, a mingling of all classes including the Catholic clergy, resembles the descriptions given in eyewitness accounts. The surprising detail in the foreground, which shows a well-groomed man having his palm read by a gypsy, gives an odd turn to the painting that further complements the references to Calvinism. Calvin evidently was sufficiently upset by the inroads of such superstitions that he devoted a special pamphlet to a denunciation of palmistry. There are other details worth mentioning: the man who holds his nose at the smell of the poor, and the vacuous, dazed stares of the pious listeners. All of these things give a touch of satire to the painting, suggesting that Bruegel regarded the Calvinists with as much skepticism as he showed to their religious rivals. There is also the possibility that the Iconoclastic Riots, launched against the churches by the Calvinists in August 1566, might have encouraged Bruegel to satirize the sect that had destroyed so much religious art.

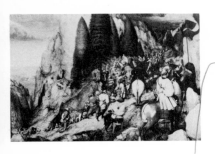

9. THE CONVERSION OF SAINT PAUL (1567), panel, 42½″ x 61⅜″
Kunsthistorisches Museum, Vienna

Although a number of art historians have categorically denied that this painting has anything to do with the Duke of Alva, who came to the Netherlands to enforce the Inquisition and establish martial law in the year it was painted, there has been no argument presented that can override the evidence within the painting itself. The subject comes from the *Acts of the Apostles* 9:1-22, which relates that God struck Saul from his horse and blinded him as he led an army to persecute the Christians. When Saul converted to Christianity, becoming the Apostle Paul, his sight was restored.

Although the subject was quite popular in Italy and had been depicted in the North by Lucas van Leyden and Jean Bellegambe, Bruegel's Alpine setting is peculiarly appropriate as a route the Duke might have taken to avoid passing through hostile French territory. Bruegel's version is also unique in that he shows a horseman in black witnessing the Apostle's affliction, which is shown from a great distance, unlike other versions in which Paul's abrupt unhorsing is emphasized. This suggests that Bruegel is expressing the hope that the Duke, who was usually clad in black, might learn from Paul's example. If the Spanish armor is inaccurate, as some scholars seem to think, then it may be that the painting was completed before the Duke's arrival. However, the presence of the Imperial insignia on a partially hidden shield carried by a soldier near the center of the picture and on a banner at the far right seems to leave little doubt about Bruegel's underlying purpose.

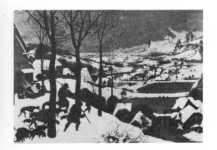

10. HUNTERS IN THE SNOW (1565), panel, 46″ x 63¾″
Kunsthistorisches Museum, Vienna

The series of the occupations of months, to which this painting belongs, was completed for Niclaes Jonghelinck by February 1566, perhaps as decoration for his palatial home in Antwerp. The occupations shown here suggest January and February, according to a tradition that dates back at least to the Duc de Berry's book illuminators early in the fifteenth century. It may seem unreasonable to look for moralistic ideas in a painting as beautiful as this one, which focuses with astonishing clarity on objects near and far, but there are a number of indications throughout the series which leave the impression that Bruegel could not resist his characteristic inclination to give instruction with his entertainments. Sebastian Brant's comments on the folly and wastefulness of hunting and poaching seem appropriate here, and there is also the contrast between some people who are industrious and others who playfully skate on the ice in the valley below. The composition features a crossing of two diagonal lines; the hunters and dogs crossing the raised triangular plateau to merge with the diagonals that move towards the right. Here as elsewhere in the series, Bruegel shows himself an

outstanding landscapist, sensitive to the significant form of each detail, no matter how far off and minute, yet conscious of his role as organizer and creator of artistic unity. In his earlier landscapes humanity played a less significant role. Now man and nature are one, united in the functional processes of nature and life.

11. THE HARVESTERS (1565), panel, 46½″ x 63¼″
Metropolitan Museum of Art, New York, Rogers Fund, 1919

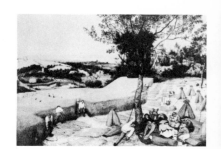

As part of the series of the months, this painting may represent July and August. Again there is a contrast between the industrious and those who take life easy. The dozing man sprawled in the central foreground area, for example, foreshadows a figure of a wastrel in *The Land of Cockaigne* (Slide 16) and seems to suggest certain lines from *Ship of Fools* which warn that "with grief in winter shall he pay" who "in summer would neglect his work and slumber 'neath the sun." In comparison, Brant praises the industrious man who gleans "in summer's heat so that in winter he may eat."

The composition is dominated by the broad sweeping curve of the field of unharvested grain, but Bruegel has acted to stabilize its powerful drift to the right by closing it in with a green hedgerow in the background, and giving a strong emphasis to the large tree and the group that is eating in its shadow.

12. WEDDING DANCE IN THE OPEN AIR (1566), panel, 47″ x 62″
Detroit Institute of Arts

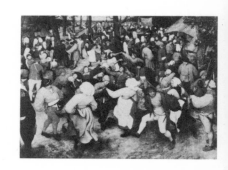

When this picture was cleaned in 1942, it became clear that it was more than a simple genre representation, for the faces and postures show that a mixture of drinking and dancing between the sexes leads to lustful behavior. The puritanical attitude against dancing was shared by most theologians in the sixteenth century, but reached its highest level in Calvin's Geneva, where dancing that merged the sexes was punishable by confinement in prison. Even the bride, her red hair streaming under a wreath, has left her place at the table in the background, where a drape and crown are suspended between two trees, to dance to the sinful music of the bagpipers. It is not clear who the groom is, but there is a wistful on-looker near the bagpipers, and a similarly dressed figure towards whom the diagonals of perspective converge in the background turns his back on the festivities. Is it possible that he is the missing groom? Or is he the artist, standing apart and sadly observing the folly of his fellow men who have turned the holy sacrament of marriage into an excuse for having a good time?

The most interesting composition is structured by two diagonals crossing in the distance, and features a series of poses that catch the movements of the dance; but even more fascinating is the way in which Bruegel has spotted areas of red, white, and other colors throughout. This manner of creating subsidiary patterns within the total composition, which recalls his use of the disc motif in the *Triumph of Death* (Slide 3), shows Bruegel's attentiveness to the abstract elements of design. Moreover, in combining this earlier device with his newer style, which is based upon large unities of form, he reveals his ability to build and grow with experience and experimentation.

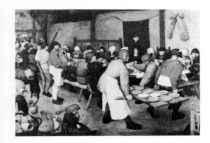

13. WEDDING BANQUET (c. 1567), panel, 44⅞" x 64⅛"
Kunsthistorisches Museum, Vienna

As in the Detroit painting (Slide 12), the artist is commenting upon our disgraceful misconception of the significance of the marriage sacrament, but here the attack is directed more at gluttony and ostentation, which are combined in the child in the foreground who gobbles food and wears a peacock's feather, a symbol of pride. The bride is seated in front of a blue hanging under a gay crown, but again Bruegel gives us no definite clue as to the identity of the groom.

A strip of more than seven and a half inches has been added to the bottom of this picture, probably replacing an edge that had been damaged or removed earlier, but this does not detract from the overall force of the painting. The composition features a strong diagonal sweep to the left, but it is stabilized by the posts that support the roof, and by the powerful standing figures of the bagpipers and those who are serving the guests.

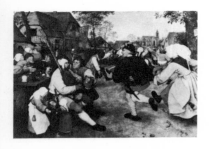

14. THE PEASANT DANCE (c. 1567), panel, 44⅞" x 64⅝"
Kunsthistorisches Museum, Vienna

If we are to judge from the large banner and the placard depicting the Madonna that is fastened to the tree at the right, the subject of this painting is a kermess, a festival to commemorate a saint's day. The composition exemplifies Bruegel's late style, which becomes increasingly simple and monumental, using fewer figures seen from a closer, eye-level point of view. The result is a stronger sense of unity, which paradoxically provides the artist with an opportunity to give each figure a more individual character.

In the group at left, several of the Seven Deadly Sins are exemplified. The man talking to the bagpiper, for example, wears the peacock's feather, while gluttony, anger, and lust are enacted by other characters. Perhaps the remaining sins are implicit, and the children

are about to follow the examples of their elders. The walnut shells under the dancer's feet foreshadow the imagery in one of Jacob Cat's emblem books, published about sixty years later, in which monkeys dancing to a bagpiper's tune ignore the walnuts being showered from the heavens by God, to symbolize that Grace is wasted on sinners. The whole atmosphere is noticeably far from religious, and the holy images and the deserted church in the background are ignored in this telling portrayal of the meager significance of a religious holiday for the average man.

15. THE MAGPIE ON THE GALLOWS (1568), panel, 18⅛″ x 20″
Hessisches Landesmuseum, Darmstadt

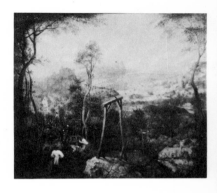

In this late work the presence of magpies at and near the gallows may have been given too much significance by some observers who took Carel van Mander, Bruegel's earliest biographer, too seriously. According to Van Mander, the magpies represent gossipers who are fit only for the gallows. However, Bruegel hardly ever used bestiary symbolism after dropping his Boschian style some ten years before he painted this small but brilliant landscape. Some scholars have suggested that this painting contains political references, showing popular resistance to the Duke of Alva's stringent regime; however, it is. more likely, because of the vigor with which the Duke pursued his quest for subversives, that Bruegel's commentary here is a generalized one.

As in so many of his works, Bruegel seems to be making his usual contrast between two ways of life. The revelers on the hill contrast with the industrious millers on the lower plateau, just as the path to the gallows contrasts with that of the cross. One signifies a disgraceful end, easily reached; the other, a dignified and meritorious sacrifice at the end of a laborious ascent.

16. THE LAND OF COCKAIGNE (1567), panel, 20½″ x 30¾″
Alte Pinakothek, Munich

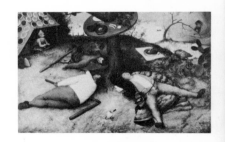

In this depiction of a fool's paradise, Bruegel illustrates a popular literary subject which makes fun of those who think that "the world owes them a living." Some historians see the picture as a reflection on the success of the lotteries that had been instituted by the regent Margaret of Parma to raise revenue to pay her troops, a procedure which developed into still another governmental scandal when it was discovered that those who administered the lottery were the only ones to gain from it.

Bruegel also made an engraving of this same theme. The verses that accompanied the

engraving tell of those "loafers and gluttons—Farmer, Soldier, or Clerk," who get along without trying. The verses continue, "the fences are sausage, the houses are cake, and the fowl are already cooked and waiting to be eaten." In the engraving, one such obliging bird flies into the mouth of a knight who rests on a pillow under a roof covered with pies. As an interesting insight into Bruegel's sense of propriety, we should note that he has omitted the sexual fantasies that were a basic feature of the literary expositions of this subject.

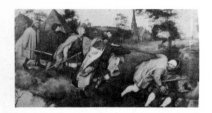

17. THE PARABLE OF THE BLIND (1568), tempera on canvas
33⅞" x 60⅝" Museo di Capodimonte, Naples

This subject, which had been used earlier by Bosch and by Cornelis Massys, apparently had great appeal for Bruegel. Blind men appear in the *Battle Between Carnival and Lent* (Slide 2), and there are paintings by Bruegel's son Pieter and by Martin van Cleve, two of his followers, which suggest that he might have created other versions which have been lost.

Blindness, as used in *Matthew* 15:14, is a metaphor for the lack of spiritual insight. In medieval as well as in sixteenth-century literature, the ditch or pit was a common symbol either of Hell or of any one of the Seven Deadly Sins. Paintings of this subject usually involved two figures and Bruegel's motive for expanding the number to six seems to have been to demonstrate that folly knows no class distinction. Even the man who wears an ostentatious cross to display his piety is among those who are being misled.

Bruegel's observation of reality is so keen that a French physician, Dr. Torrilhon, was able to diagnose five different eye diseases by studying the faces visible in this picture. The church, which these men have bypassed in their blindness, can be seen at a distance, framed by trees and the outstretched staff which pulls its bearer to perdition.

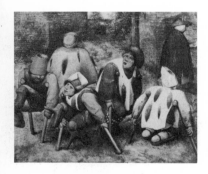

18. THE CRIPPLES (1568), panel, 7⅛" x 8½"
Louvre, Paris

Figures similar to these appear in Bruegel's *Battle Between Carnival and Lent* (Slide 2), and among his drawings from life. Bosch had preceded Bruegel in depicting pages full of drawings of cripples showing almost relish in inventing new horrors of deformity. And, as an interesting example of the universality of ideas, the Chinese artist Chou Ch'en created a series of sketches of beggars in 1516 as an "admonition to the world." This seems to be Bruegel's intention as well. The supposition that these cripples refer to the *Gueux*, the famed beggars who took up the cause of the Netherlands with the foreign rulers, does not bear scrutiny.

The hats worn by these poor wretches, the red "crown" and the white paper "bishop's miter," suggest various levels of society, and show that this savage little painting is more than a study in genre. The various deformities and ineffectual means of locomotion of these cripples may have metaphorical significance as reflections of the handicapped nature of man in his pilgrimage through life.

19. THE PEASANT AND THE BIRD-NESTER (1568), panel 23¼" x 26¾"
Kunsthistorisches Museum, Vienna

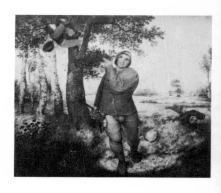

Although this simple exposition of two contrasting ways of life has been subject to numerous diverse interpretations, the motifs are clearly derived from *Ship of Fools*. Brant uses the imagery of the nest robber to describe the predator who risks life and limb in pursuit of worldly vanities:

> The fool may tumble painfully
> Who climbs for nests upon a tree
> Or seeks a road where none is found

In another verse he portrays the man whose smugness and self-righteousness mean an acquiescence to evil, as one who becomes mired in the pit that traps the spiritually blind. Thus Bruegel again compares two ways of life: that of the self-centered evildoer and that of the smug person who points to the wickedness of his fellow men but does nothing to stop them.

The painting contains some of Bruegel's most accomplished landscape passages and a powerful concept of the figure that competes with the Italian High Renaissance style. The composition is more complex than one realizes at first glance. The undulating line of the brook is effectively echoed in a procession of vertical tree trunks that lead to the walking peasant, and then to a series of horizontals that is stopped by a house and tree at the right.

20. THE MISANTHROPE (1568), tempera on canvas, 34⅝" x 34⅝"
Museo di Capodimonte, Naples

The engraving of the same subject (Figure 21) helps us to interpret the meaning of this painting. In its background, robbers attacking a wagon are contrasted with a man entering a mill, creating a significant linkage to Bruegel's other works in which different ways of life are compared (e.g., the engraving *Elck,* Figure 5, and the painting *The Peasant and the Bird-Nester,* Slide 19). This suggests that the major figures are to be contrasted in the same

way, and that the bucolic setting in which a shepherd tends his flocks in the painting represents a third and preferable approach to life. The purse-snatcher crouching in the orb-and-cross, appears in the *Netherlandish Proverbs* (Figure 7), illustrating the proverb "You have to stoop low to get along in the world." In the same painting the symbol is used to identify a false, flaxen-bearded Christ, to show contempt for an upside-down world, and to suggest how easy life is for a courtier who balances the world on his thumb. Evidently the purse-snatcher, a "cousin" of Elck and the bird-nester, is the socially aggressive, worldly-wise man who victimizes his fellows. The other figure in black mourning represents those who retire from this sinful world, and, like Nemo or the peasant, do nothing to fight evil. As a final word, we should also note that an orb-and-cross device was part of the official paraphernalia of the Holy Roman Emperor, symbolizing the union of church and state, so that it is possible that the forces of evil have been given a more specific identity than is at first apparent.

SELECTED BIBLIOGRAPHY

Bastelaer, Rene van: *Les Estampes de Pieter Bruegel l'Ancien* (Brussels, 1908)
Grossman, F.: *Paintings of Bruegel* (London, 1966)
Klein, A.: *Graphic Worlds of Pieter Bruegel the Elder* (New York, 1963)
Münz, Ludwig: *Drawings of Pieter Bruegel the Elder* (London, 1961)
Stridbeck, C. G.: *Bruegelstudien* (Stockholm, 1956)
Tolnay, Charles de: *The Drawings of Pieter Bruegel the Elder* (New York, n.d.)

F